CHARCOAL DRAWING

By Ken Goldman

Walter Foster Publishing, Inc.
23062 La Cadena Drive, Laguna Hills, CA 92653

Notice: All figure and portrait renderings have been drawn directly from imagination or from paid professional models. Any likeness to persons other than those hired for the purpose is purely coincidental.

Contents

Introduction

Charcoal drawing is as old as the discovery of fire. When primitive peoples sat around camp-fires, charring sticks of wood and drawing on flat stones, they were practicing the art of charcoal drawing. Today charcoal is still made the same way: vine, willow, and other twigs are charred in hot ovens for use as vine charcoal (charred coal), the type most commonly used by artists. In addition to vine, there are charcoal pencils and compressed charcoal sticks that come in varying degrees of hardness. Both beginners and professionals appreciate the rich expressiveness of charcoal. I used charcoal when I first started drawing, and it is still my favorite sketching medium.

I enjoy drawing and painting just about anything visible in everyday life—landscapes, still lifes, interiors, street scenes, seascapes, flowers, birds, animals, portraits, and figures. I believe that learning *how to see* is the primary issue in drawing, not what is chosen as subject matter. For this reason, illustrating these pages has been exciting, because I've included many of the subjects that I most enjoy from the three kingdoms of nature—minerals, plants, and animals. Thinking of both beginning and advanced artists, I have organized the subject matter into a progression from easiest to most complex. I believe that as the "spark" or essence of life becomes more evident, each kingdom gets increasingly difficult to draw; to capture the spiritual essence of human beings in a portrait or figure drawing is the most difficult drawing task.

The purpose of this book is two-fold: (1) to teach the basic techniques of drawing and (2) to show how to develop an "artist's eye." Developing an artist's eye means learning to see very clearly without seeing too much; that is, seeing essentials while dismissing superfluous details. It means learning to see shapes, curves, lines, and angles while at the same time knowing that they are only parts of a larger whole. It also means learning the strokes, textures, and values that are the language of charcoal drawing and the ways to compose these elements on a page. Each page in this book covers a different aspect of drawing. Some pages will seem to repeat a lesson because the "ways of seeing" taught in the beginning exercises are basically the same as those taught for more complex projects. Advanced artists can begin in the back, flipping through the beginning for a brushup on basics, while beginners will want to work through the first part and progress to the end.

Materials

One reason why charcoal drawing is so appealing is because of its simplicity. Most of the materials shown below can be carried in a small bag. Use a small sketch pad for travel and a clipboard and large sheets of paper for larger, ongoing projects.

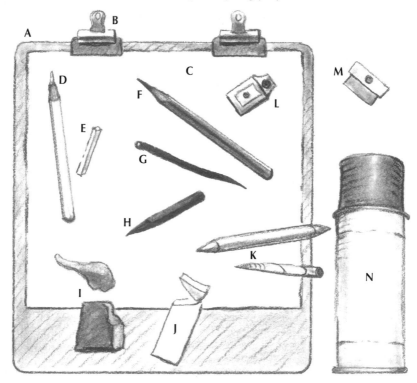

(A) **Masonite clipboard or foam board**—for a drawing surface.

(B) **Clips (or tape)**—to hold the paper to the drawing board.

(C) **Charcoal paper**—use several sheets for padding.

(D, E) **Soft white chalk and pencil**—for accents on darker paper.

(F) **2B, 4B, or 6B charcoal pencil**—6B is softest; 2B is hardest.

(G) **Vine charcoal**—a good all-around charcoal for beginning artists, because it is easy to erase and blend. Sharpen one end.

(H) **Compressed charcoal**—has a binder, makes rich darks. It is harder to erase and more permanent than vine charcoal; good for finishing work.

(I) **Kneaded eraser**—pull off a small piece for lifting details, or use the biggest part for erasing and softening large areas.

(J) **Vinyl eraser**—more aggressive than a kneaded eraser. Cut off a small, sharp piece for creating textures, softening edges, or erasing detailed light areas.

(K) **Stump**—use for blending large or small areas.

(L, M) **Sharpeners**—use either instrument for sharpening. Razors make a long, delicate tip for soft, gradual shading.

(N) **Workable fixative**—use it to fix vine charcoal as you progress and again at the end to protect the drawing.

Basic Hand Positions

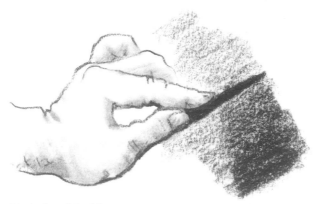
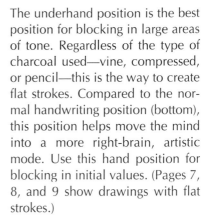

Underhand Position

The underhand position is the best position for blocking in large areas of tone. Regardless of the type of charcoal used—vine, compressed, or pencil—this is the way to create flat strokes. Compared to the normal handwriting position (bottom), this position helps move the mind into a more right-brain, artistic mode. Use this hand position for blocking in initial values. (Pages 7, 8, and 9 show drawings with flat strokes.)

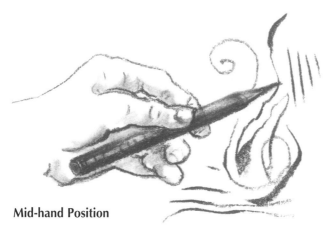

Mid-hand Position

The mid-hand position is used for live figure drawing when you want a wide range of expression but do not want to "tighten up" too much. Hold the charcoal lightly so you can vary its pressure, and use this position to develop the initial lines and angles of your drawing. If you are careful at this stage, twisting and varying the charcoal as you push or pull it, the resulting lines will be accurate and expressive.

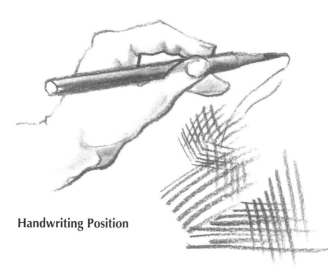

Handwriting Position

The handwriting position is used for greater control and detailing. It is best, however, to use this position toward the end, because details and accents should first have a foundation on which to rest. When you work this way, it is easy to smear the drawing with your palm, so place a clean sheet of paper under your drawing hand. Whereas the other two hand positions keep the charcoal sharp for a while, this way of working dulls the tip quickly, which will affect the delicacy of your strokes. Sharpen your charcoal often.

Textures, Lines, Strokes, and Tones

There are seven elements of design: color, value, line, texture, size, shape, and direction. These are the tools that artists use to create the illusion of three-dimensional space on a two-dimensional surface. It is often said that feelings of color can be sensed even where none exists if all the elements—especially value—are used in proper relation to one another. The techniques shown below, when used appropriately, will help to enliven your drawings.

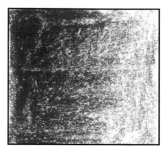

Gradation: Use the underhand position to create a full range of values (see drawing on next page).

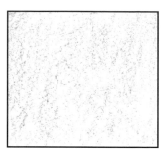

Flat Shading: Use the underhand position to shade large areas. This stroke is for generalized halftones.

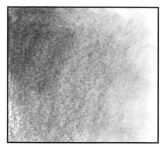

Blending: Use a stump or finger to create subtle value passages and soft edges. See pages 7, 8, and 9.

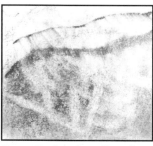

Eraser Strokes: Cut off a sharp piece of vinyl eraser or use a small piece of kneaded eraser to soften edges and vary line quality (or use white chalk). See page 27.

Expressive Lines: Use the midhand position. Push, pull, twist, and vary pencil pressure as you draw a line. Study Degas or Egon Schiele to help you understand expressiveness.

Dotting: This technique creates texture on a wall, carpet, or parts of the ground. Use your imagination and vary the pressure.

Cross-Hatching: This technique is a great way to enhance form in conjunction with shading and blending. The more strokes that crisscross one another, the darker the passage. See page 41.

Linear Hatching: Use flat, medium, or thin strokes in one predominant direction. Darken or lighten values by increasing or decreasing pressure. See page 17.

Squiggles: Just one of many textural possibilities (i.e., smoke, bark, rocks). Use in conjunction with hatching to increase straight or curve contrasts.

The Value Scale

Nature presents itself to the eye as color, shape, and value. Because charcoal drawings are done with black, white, and shades of gray (the value scale), you must pretend that your eye is loaded with black-and-white film and translate the colors you see in nature into shapes of corresponding values. Many artists simplify nature's hundreds of subtle values into ten values, but five is plenty—and fewer values actually make a stronger visual statement.

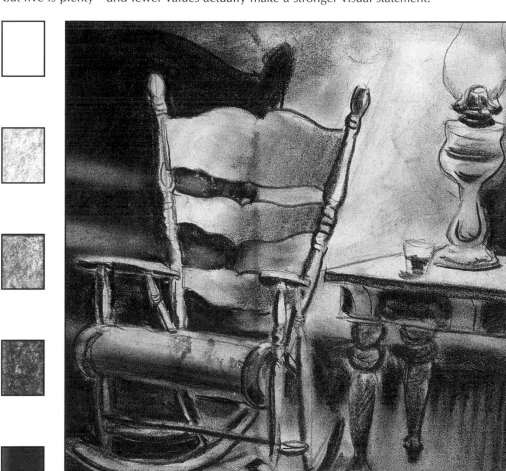

This study (artist unknown) was drawn with a flat stick of compressed charcoal and a kneaded eraser. In this case the charcoal acts as shade and the eraser as light. Here, the purpose of the eraser is not so much to correct mistakes but, like white paint in oils, to mold the drawing and develop a sense of volume and lighting. Also notice the deliberate variations in line, tone, and soft, medium and hard edges. See pages 8 and 9.

Low and High Contrast in Value

When studying your subject and choosing tones from the value scale, it is important to decide how much contrast you see between darks and lights. If a subject consists mostly of grays (i.e., the lights are not too bright and the darks are not too black) it is said to have low contrast. On the other hand, a full-contrast subject has bright whites, dark grays, or blacks, and various shades of gray in between. The drawing below has a low degree of contrast while the picture under it has a high key of contrast.

Low Contrast

Compare this drawing to the picture below it. A light brighter than the lantern has been turned on, and all the mystery and drama have vanished with the darkness. Even though the paper in this picture is white, the lack of contrasting darks makes the viewer's eye think that there is no brilliance.

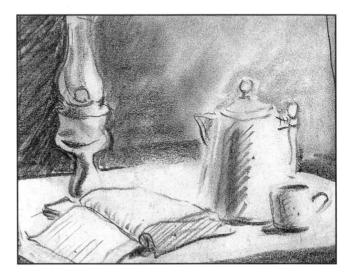

High Contrast

There can be a sensation of bright light only if there is a deep darkness surrounding it. This drawing has only four values: white, light gray, dark gray, and black. There is no middle tone. This kind of value structure ensures a feeling of brilliance. Compare this drawing to the picture on page 9, which also has only four values. The difference is middle-tone gray. A value structure where middle-tone gray is included conveys a sensation of glowing luminosity rather than the stark brilliance of this drawing.

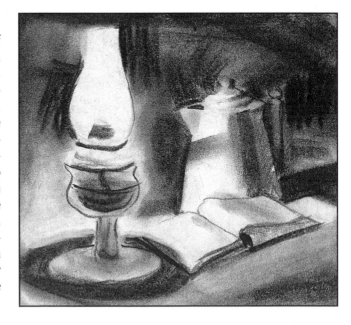

Lost and Found Edges

Edges occur whenever two or more different forms or values meet. The degree of hardness or softness of an edge is determined by how these changes occur. The softest (lost) edges occur when a transition from one value to another is so gradual that there is no discernible point of change. The hardest (found) edges occur where different forms or values meet abruptly.

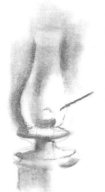

The right side of the lantern shows a lost edge in the light, while the left side shows a found edge bordered by darkness. Imagine how boring this lantern would be if both sides were the same.

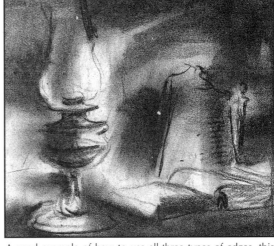

Even though this edge is bordered by a light background, notice how the contour is slightly blurry. This drawing is an example of a medium edge between the extremes of hard and soft.

A good example of how to use all three types of edges, this study was drawn with compressed charcoal, a kneaded eraser, and a stump.

Variations in Soft, Medium, and Hard Edges

Hard edge—light against dark; soft edge—medium against medium.

Hard edge—light against dark; medium edge—medium against medium; soft edge—light against medium light.

All three edges plus a straight-against-curved contrast.

A powerful focal point can be created by placing the lightest light, the darkest dark, and the sharpest edge all together at the same meeting point on your paper. In addition, if all other areas are subordinated to the focal point—yet have enough variation to keep the viewer's eye moving and interested—your picture is probably a compositional success. Interesting edges and well-placed light and dark accents can make or break a drawing.

Perspective: Cylinders

Eye level is an imaginary line that is horizontal with your eyes when you look straight ahead at an object or view. If you lie down, your eye level is low like a "worm's-eye view." If you are above what you are drawing, your eye level is high like a "bird's-eye view."

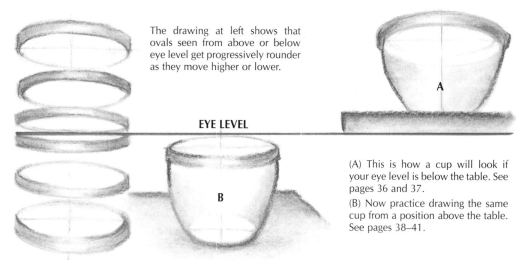

The drawing at left shows that ovals seen from above or below eye level get progressively rounder as they move higher or lower.

A

EYE LEVEL

B

(A) This is how a cup will look if your eye level is below the table. See pages 36 and 37.

(B) Now practice drawing the same cup from a position above the table. See pages 38–41.

Find a paper towel roll and sketch it from all angles. It is worthwhile practice, because a cylinder is the basis for many common forms—even arms and fingers. Make sure the ends of the cylinder appear to converge as they retreat into the distance.

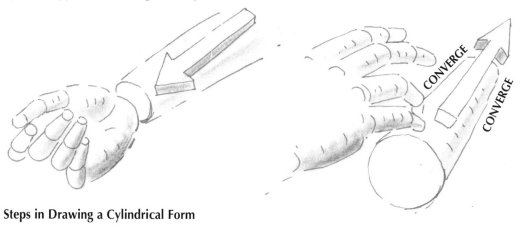

Steps in Drawing a Cylindrical Form

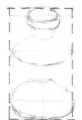

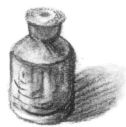

(1) **Proportions:** Divide width into length to find accurate measurements.

(2) **Contours:** Lightly sketch the ovals in correct perspective.

(3) **Volume:** Render the forms using a piece of vine charcoal, a stump, and a kneaded eraser.

Perspective: Cubes and Rectangles

One-point perspective occurs when the parallel sides of an upright cube or rectangle converge into a vanishing point (VP) on the horizon line (your eye level). Two-point perspective occurs when the horizontal lines of a cube recede toward two vanishing points. The vanishing points can't be too close together, or there will be distortion.

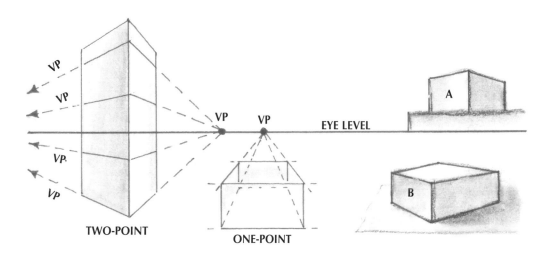

TWO-POINT **ONE-POINT**

Rectangle A (above right) is on a tabletop above eye level, whereas rectangle B is on a table below eye level Draw many rectangles from different perspectives, and then consider doing more complex still lifes, such as those on pages 36–41.

Steps in Drawing a Rectangular Form

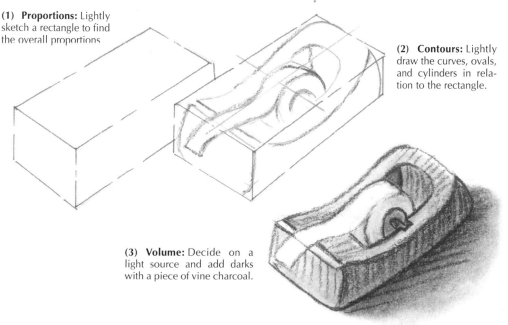

(1) Proportions: Lightly sketch a rectangle to find the overall proportions

(2) Contours: Lightly draw the curves, ovals, and cylinders in relation to the rectangle.

(3) Volume: Decide on a light source and add darks with a piece of vine charcoal.

11

Turning Shapes into Forms

When drawing on paper, shapes appear flat (two dimensional) and forms appear to have an illusion of volume (three dimensional). Small children only see and draw flat shapes, because perspective, shading, and creating form are learned skills.

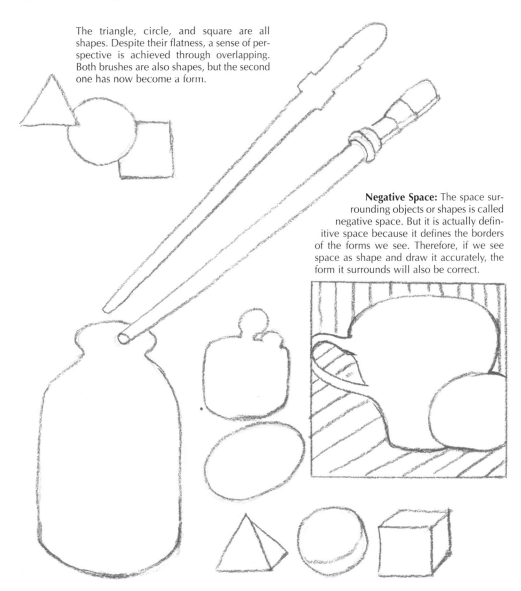

The triangle, circle, and square are all shapes. Despite their flatness, a sense of perspective is achieved through overlapping. Both brushes are also shapes, but the second one has now become a form.

Negative Space: The space surrounding objects or shapes is called negative space. But it is actually definitive space because it defines the borders of the forms we see. Therefore, if we see space as shape and draw it accurately, the form it surrounds will also be correct.

Notice that the triangle, circle, and square have now become forms. On page 13, the shapes shown above have become forms in a composition. The greatest challenge for beginning art students is to leave the security of only drawing outlines around shapes and to give dimension to forms with cross-contour lines and modeling (see page 59). Many great artists (e.g., Picasso, Kandinsky, Matisse) deliberately abandoned their training to pursue a more childlike vision, but they were already masters in classical draftsmanship. Few artists can be successful in abstract or nonobjective art if they do not have a thorough understanding of the basics.

Organizing Forms into Compositions

The way you arrange various shapes and forms on your page is referred to as composition. A good composition is dynamic; a poor one is static. All the forms on this page could be taken apart and placed randomly, but instead they have been thoughtfully arranged. There are many rules and formulas for good composition and plenty of books about it. If you remember to keep objects off center and add contrast to the seven elements of design (see page 6), you will find composition in art to be as natural as tastefully composing a plate of food for dinner.

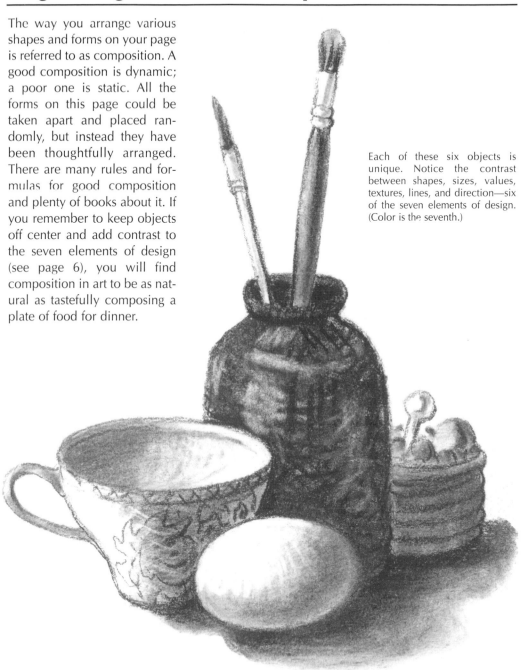

Each of these six objects is unique. Notice the contrast between shapes, sizes, values, textures, lines, and direction—six of the seven elements of design. (Color is the seventh.)

Notice how the teacup, its handle, the egg, and two jars all have oval shapes; these repetitions help to create unity. Also observe how the angle of the left brush echoes the left angle of the teacup and how the round object in the jar at right echoes the right side of the cup. Other contrasts include: a smooth egg next to a textured cup and jars; a dark jar against a light egg; and vertical brushes against horizontal shapes. Look for these principles throughout the book.

Drawing with an Eraser

Using the side of a vine charcoal, tone an entire sheet of white paper. Blend the charcoal by softly rubbing a paper towel or chamois cloth over it. Lightly draw an image, pick out light areas with a kneaded eraser, and add darks with sharpened vine. As the image progresses, finish with a charcoal pencil and, if necessary, add a few finishing accents with white chalk.

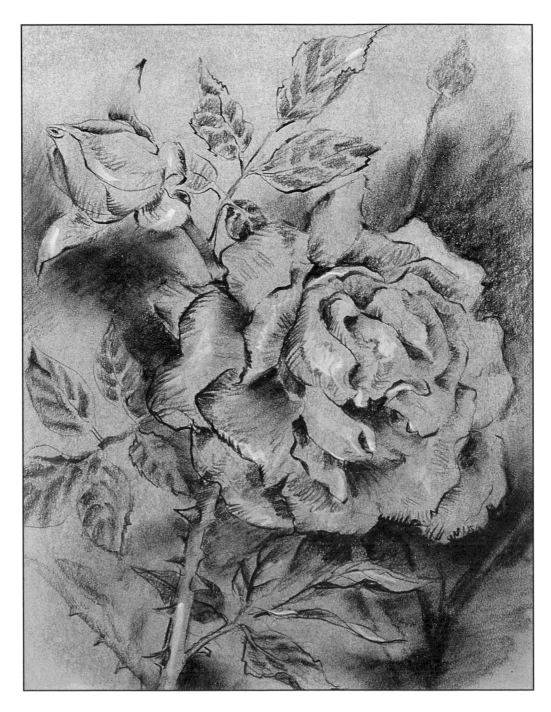

Stages of a Drawing

The development of a drawing is similar to building a house; it is a basic sequential process. If you follow the construction sequence step by step, many pitfalls will be avoided.

These four stages may seem mechanical, but they offer a good place to start a charcoal drawing. I find these steps especially useful in figure drawing. See pages 54–57.

(1) Building the Foundation: When beginning a sketch, use light, straight lines; they are better than curved lines because they do not follow minor details. Make sure you draw the angle of each line correctly. Form and perspective are only correct if the angles that compose them are correct. Try this by looking through a window and tracing a difficult scene on it with a grease pencil or marker. Your perspective will be accurate without even trying because all the angles and proportions will be correct.

(2) Framing the Structure: If you have a firm foundation (i.e., straight lines with accurate angles in correct proportion), you are ready for this stage. Every difficult form resembles a simple geometric form (cube, sphere, cylinder, or cone). Find the geometric form that is closest in shape to your subject and draw it. For example, a cylinder is much easier to draw than an arm, and it readily gives you the mass and direction of the arm as well as a foundation for drawing the final contours, tones, and accents. See pages 45 and 51.

(3) Adding the Walls: Now you have a solid structure, so you can begin adding the walls (actual contour lines of the shape you are drawing). Because these contours are based on volumes, it will be easy to create an illusion of three dimension.

(4) Final Details: Add details, shading, and accents to create roundness and finish. This is the part of a drawing that most people notice, but discerning eyes are not impressed by facility unless the drawing underneath is equally proficient.

Flowers and Minerals

Flowers and minerals are good subjects for charcoal drawing because they embody many design principles and do not require as much experience. It is also interesting to see how various shapes have aesthetic similarities. For example, the desert rose (below) is almost a frozen version of the living rose (right). Or think of how certain orchids resemble butterfly wings. If you think about nature with ideas such as these, you can develop a dimension of childlike wonder that leads to artistic curiosity and a stronger desire to explore nature through drawing.

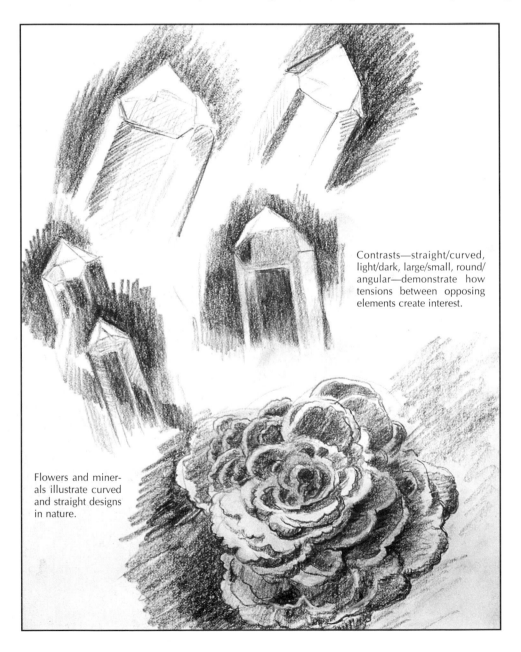

Contrasts—straight/curved, light/dark, large/small, round/angular—demonstrate how tensions between opposing elements create interest.

Flowers and minerals illustrate curved and straight designs in nature.

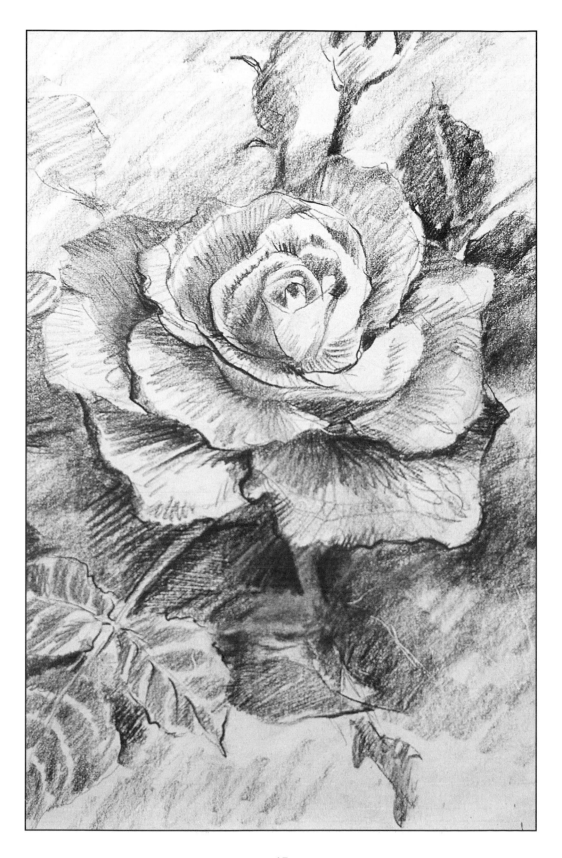

Iris

Vine and Compressed Charcoal—The backlit petals of an iris during sunrise or sunset create a drama of light and darkness perfectly suited for charcoal work. Making preliminary charcoal studies of flowers such as these can help you understand values, which later will serve as the basis for further work in color.

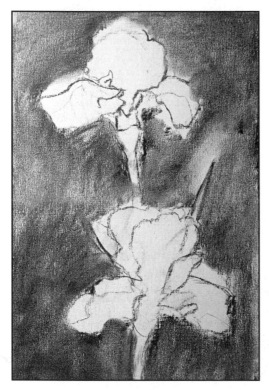

Step 1: Make a light sketch using the sharpened end of a piece of thin vine charcoal.

Step 2: Then take a piece of thicker vine charcoal and tone the whole paper with flat strokes. Using your finger, a chamois cloth, or a paper towel, blend it and slowly build up the darks.

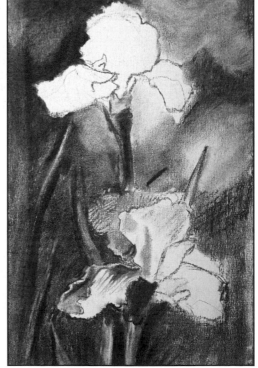

Step 3: Now use a stump to blend smaller detailed areas such as the petal on the lower left, which shows a cast shadow, fringes, and veins. Because the light source is on the left, you must draw each petal, keeping highlights, shadows, and cast shadows in mind. Also, limit all main shadow tones on the flowers to a light- or middle-tone range so the white flower petals will convey luminosity.

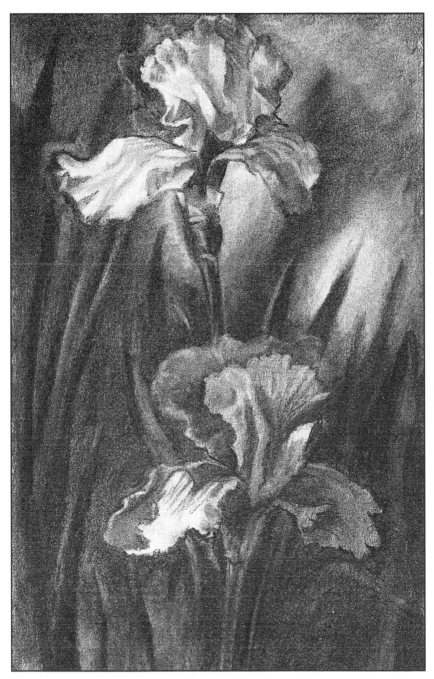

Step 4: Vine charcoal is a good medium for charcoal drawing because it is so forgiving. Sometimes it seems to come off too easily; but if you keep building it up slowly, it does get darker, and it will stay dark if you apply a little fixative between layers.

Common Sunflower

Vine Charcoal—This type of sunflower is a relative of the larger garden variety made famous by Vincent van Gogh. It is less complex and therefore a good starting point.

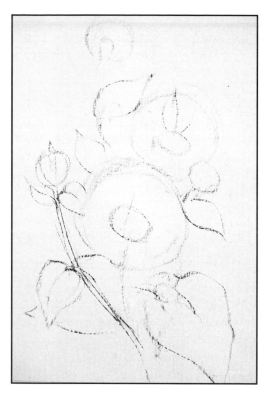

Step 1: Even with a simple drawing like this, placement is important. Begin with light, generalized construction lines for the buds, flowers, leaves, and stems. Keep the thrust moving to one side so there is a dynamic tension between the empty paper and the busy flower. If you just plop buds, leaves, and flowers in the middle, you will get a static balance, and the viewer's eye will quickly lose interest. When you are pleased with the general placement of the subject, begin to draw details.

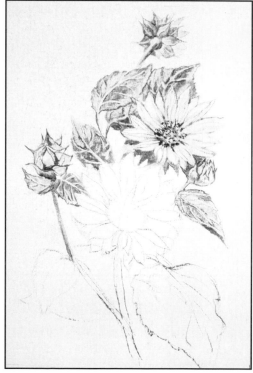

Step 2: In a botanical drawing it is possible to begin with one section and practically complete each area as you go along; however, if you are right handed, it is better to start on the left side so you do not smear what you've done already. Because the background is white, the light blossoms can only gain brilliance if darker leaves are placed behind them. Be careful with this contrast so the flowers do not feel overcrowded. Also, some light petals may need to be separated from the light background. To do this, use a few contour lines, and vary their weight and thickness to avoid monotony.

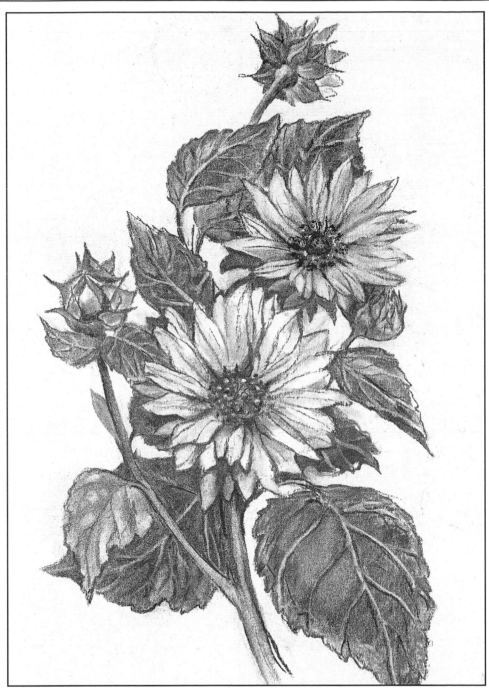

Step 3: Like the iris, this sunflower is mostly drawn and darkened with vine charcoal. It differs from the iris in that there is much more detail, so the blending is done with a stump rather than a chamois cloth. All the leaf highlights are created with a kneaded eraser, but there are a few white chalk accents in the center of the flower.

Egret

Vine Charcoal and Charcoal Pencil—The great white egret in full breeding plumage is unequaled for its elegance and unique plumes. (Hat makers used to kill these birds for their feathers.) If you decide to copy this drawing, try to capture the graceful rhythm in the neck. This quality of movement is the essence of the egret.

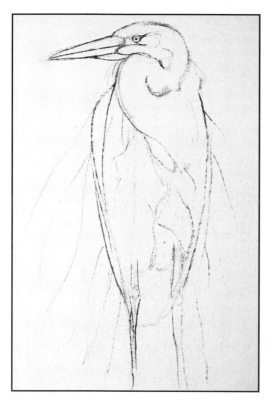

Step 1: Sharpen one end of the vine charcoal and use long, sweeping gesture lines. Drop a light plumb (vertical) line down from the eye to see where the neck and leg should be placed in relation to it. The bird's right leg is a little left of page center. Use the length of the egret's bill to its eye as a standard of measurement for both width and length. There are four bill-to-eye lengths down and one and a quarter across. As you progress, keep double-checking your measurements.

Step 2: The light is coming from above. Using vine charcoal and a stump for blending, begin to add tone. Keep the up-facing planes light and the down-facing planes dark. If you are consistent in this way of thinking, the shapes will achieve a look of three-dimensional volume. Use a kneaded eraser to help blend and shape the lights and darks.

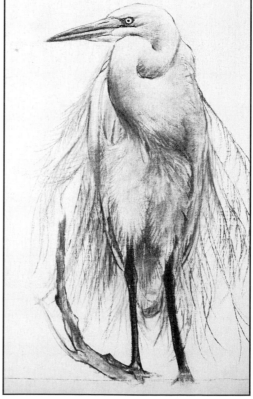

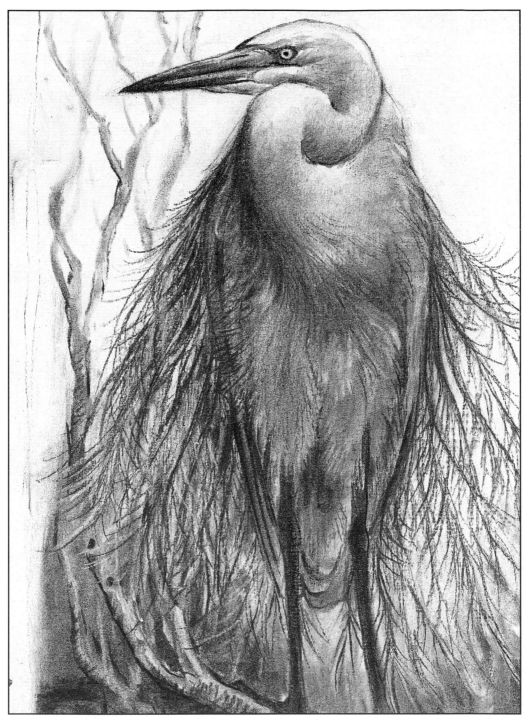

Step 3: If you want this degree of finish (which can sometimes make a drawing look too static), now is the time to add details. At first glance you might think the small strokes are done only with a charcoal pencil, but there is also quite a bit of erasing. If you slice off a small piece of vinyl eraser, you will see how well this works for detailing. Just make sure you keep the sharp edge clean by erasing on a blank piece of paper as you go along. A sharpened, compressed charcoal stick was used for the tip of the bill, legs, wings, and neck feathers.

Eagle Head

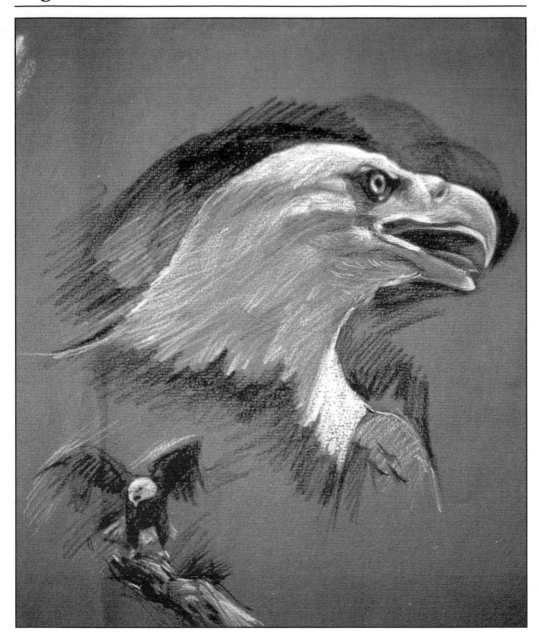

White Chalk and Charcoal Pencil on Dark Paper—This eagle head was drawn as a study for a watercolor illustration about birds of prey. Dark paper is perfect when you need to achieve a brilliant white (even the lightest touch of white yields immediate drama). Notice how the paper acts as a darker tone of light when it is allowed to show through the white chalk.

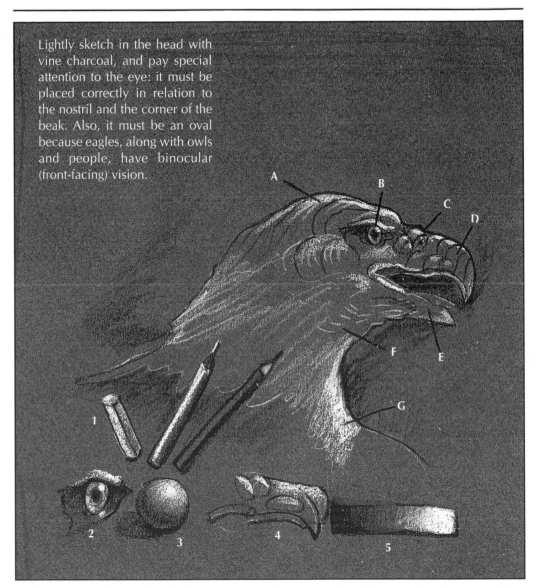

Lightly sketch in the head with vine charcoal, and pay special attention to the eye: it must be placed correctly in relation to the nostril and the corner of the beak. Also, it must be an oval because eagles, along with owls and people, have binocular (front-facing) vision.

In the diagram above, the black cross-contour lines at A, C, and D show the direction of the form. If you press down hard with the white crayon (1), you will get a very bright white (3 and 5). These examples show the importance of leaving a transition of untouched paper between the lights and shadows. This is accomplished by easing up on the light and dark pencil pressure as you approach the transition area. Notice how the eye (B and 2) is surrounded by so much dark that just a little white pastel pencil makes it seem very bright. Forms C and D on the bill are simplified to an extreme in example 4, which shows them as a modified cylinder and small egg-like shapes. On areas E and F of the bill and neck, untouched paper is showing through because its tone is perfect for describing a shadow on the white head feathers. When sunlight hits the white feathers at G, white chalk is used with full pressure.

Rhinoceros

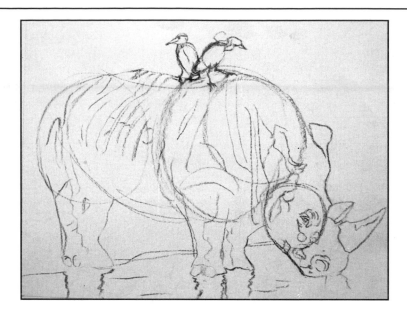

Vine and Compressed Charcoal and a Vinyl Eraser—Rhinos are massive armored tanks of the animal kingdom with great blocks, spheres, cylinders, and cones—all excellent forms for drawing.

Step 1: Use a sharpened vine charcoal to sketch in the rhino with straight lines, ovals, and circles. Then find a measurement you consider correct, such as the head length, and determine height and width. For example, a head length—from nose to ear—goes into the overall body length about three times and into the height a little more than two times (including the egrets).

Step 2: Now, with the light source coming from the left, use a stump and vine charcoal to shade the legs and wrinkles like cylinders (page 10) and the head like a block (page 11).

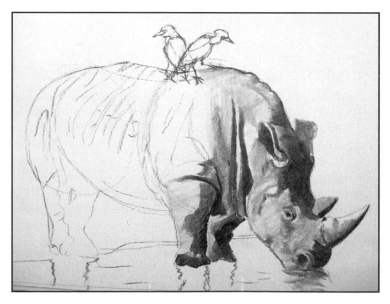

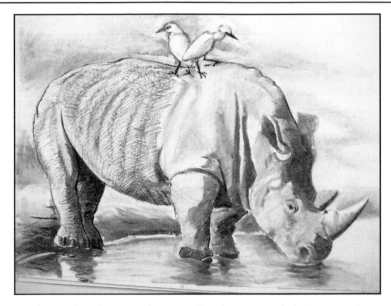

Step 3: The use of cross-hatching can be considered a personal choice. I use it mostly to avoid the overly "photographic" look of blended charcoal.

Step 4: In a further attempt to make the rhino more interesting and less static, I look back at step two and begin to emulate its good points by erasing much of the finished work. This brings more attention to the main focus of interest—the head.

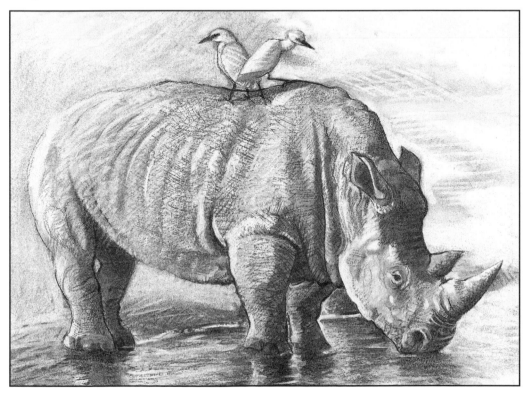

Animal Portrait

Compressed Charcoal, Vine Charcoal, and White and Gray Pastel—Your pets can be inspiring subjects for portraiture. They are habitual and repeat their positions over and over. Your observation of these characteristics will help you to convey their special personalities. For obvious reasons, a photograph is necessary for longer poses.

Step 1: In this portrait of Annabelle, likeness is a concern. Use horizontal guidelines to place the eyes, nose, and jowls, and drop plumb lines to make sure all vertical alignments are correct. Sketch lightly with a sharpened vine charcoal, and only go into details when you have checked and rechecked all shapes in relation to one another.

Step 2: Because the eyes, nose, and mouth are the crux of Annabelle's likeness, they are used as a standard for her darkest darks and greatest details. All other values and details will be subordinated to these. To achieve a feeling of fur, stroke in the underhand position (page 5) with a sharpened stick of compressed charcoal and blend some areas with a kneaded eraser. Work from the top down and from left to right to avoid smearing (right to left if you are left handed).

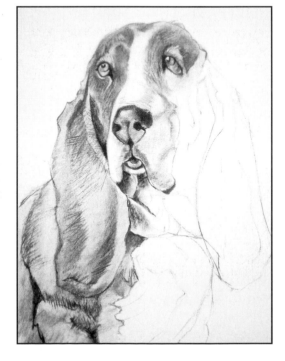

28

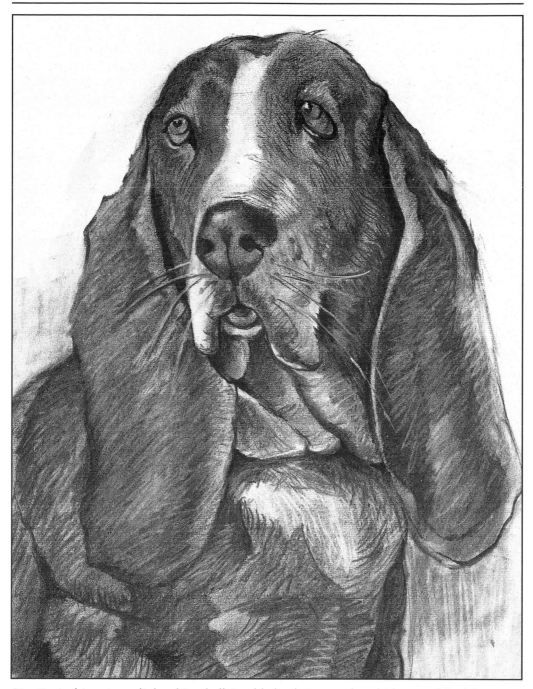

Step 3: At this point, a little white chalk is added to bring out the whiskers, and final furry textures are made with a small, sharp piece of vinyl eraser.

It is difficult to make a basset hound look any more alert than this. A friend entered the room, surprised her, and I took the photo. You will come up with many creative ways to excite your pets into that special look. Plan on using a whole roll of film to get only a few good shots.

Landscape: Three Techniques

Each of these drawings was done for a different reason in a different way.

Below: This study is from my sketchbook. I never planned to reproduce it because my sketchbook is like a diary. This was just a fun sketch done as a reminder of a beautiful place in Rhode Island. The hand was added as an afterthought, simply because I liked the idea of it. If you work with charcoal pencil on a trip, bring a small can of spray fixative or tape cover sheets over your drawings to protect them from each other.

Right, top: This charcoal study was done on location in the Borrego Desert as a value underdrawing for a pastel demonstration. I used a sturdy gray pastel paper on foam board, vine charcoal, kneaded eraser, and fixative. Details were picked out with the eraser or added in with charcoal. Vine charcoal is very delicate; you must spray it if you like a passage or it might wipe away. Unlike pastels, charcoal does not darken with spray, so it is all right to use a heavy spray at the end. This drawing became a colored pastel, but even now it would still look fine if reproduced in black and white, because its values were not altered during its translation into color.

Right, bottom: This drawing was done on a sheet of white-laid charcoal paper with vine charcoal, compressed charcoal, middle-tone gray chalk, white chalk, and a vinyl eraser. The sky is vine charcoal—rubbed, stroked, and erased; the clouds are white paper, blended with vine charcoal and accented with white chalk. The foreground tree is compressed charcoal only, and the dark trees around the white homes are vine and compressed charcoal combined. I was trying to capture the drama of tiny bright homes in contrast to a large sky and wide field. (See Walter Foster's *Landscapes in Pastel,* #HT242, for more landscape drawing techniques.)

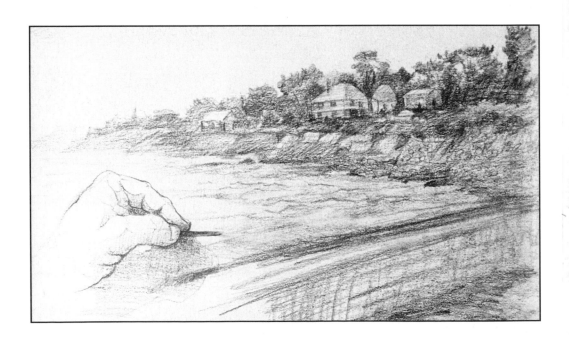

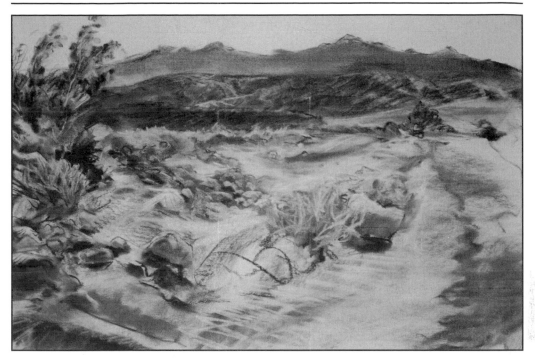

Notice how much difference there is between a pure vine charcoal landscape (above) and one that uses white and gray in addition to charcoal (below). For example, the foreground tree (below) is partially shaped by the sky that surrounds it by using white chalk the way white paint would be used in oils. The trees in the desert scene (above) are drawn with charcoal and refined with a sharpened eraser to look drawn, rather than shaped, by negative space.

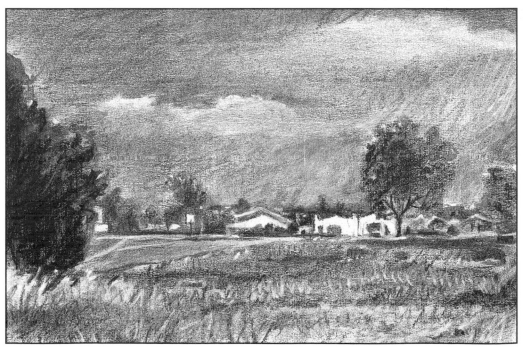

Landscape: *Sedona Spires*

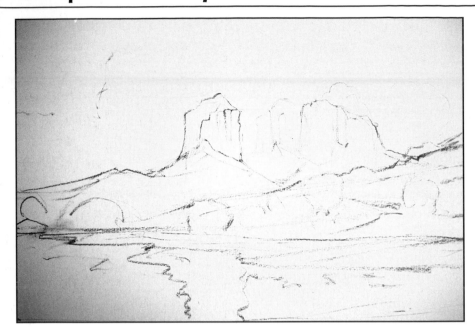

Step 1: This landscape was chosen to illustrate the use of white and gray chalks with charcoal. With a sharpened vine charcoal on white charcoal paper, lightly block in the general shapes and rhythms.

Step 2: Apply tones and blend them with a chamois cloth and your finger. To delineate clouds, use a stump against the clouds and an eraser in the clouds against the sky. At this point, the spires should be just silhouettes.

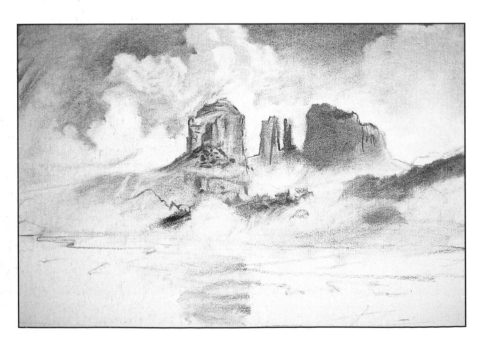

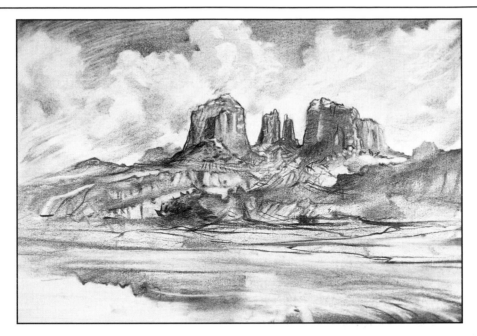

Step 3: Continue to model the sky and begin to add the darks and lights in the canyons. Cut off a sharp piece of vinyl eraser and start to erase into the light and dark hills to create trees, boulders, and erosion.

Step 4: Using sharpened vine charcoal, sketch back into the land and add dark accents where necessary. Use a piece of white chalk to indicate white water in the river and gray to add accents in the hills and sky. This kind of subject is difficult because there are so many tiny areas. Fortunately the clouds are white and quiet enough to set off the spires.

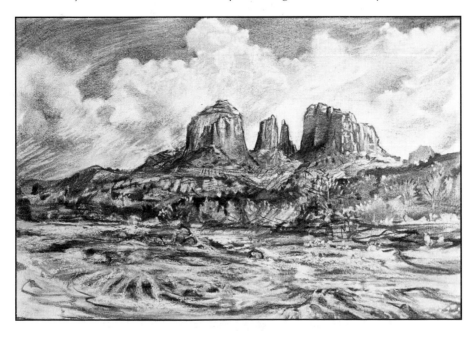

Architecture: *Presidio*

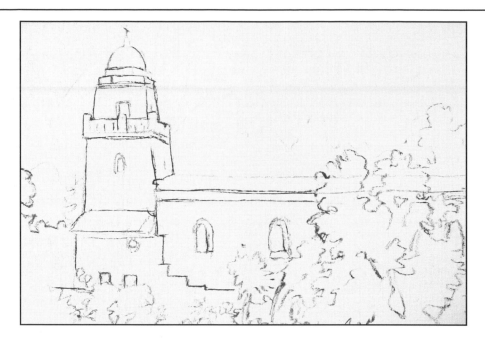

Step 1: This favorite San Diego landmark is hardly ever drawn from the front; some say the direct southwest light makes it look too flat. However, that is exactly the reason I chose this angle. I was inspired by its flat, bright monumentality. Lay the sharpened vine charcoal on its edge and pull lightly. This will help to keep the lines fairly straight. Drop plumb lines and use horizontal construction lines to ensure the windows are aligned properly with one another.

Step 2: While still using vine charcoal, mass in the darks to establish a general value range—light, middle tone, dark—and blend the foliage with your finger.

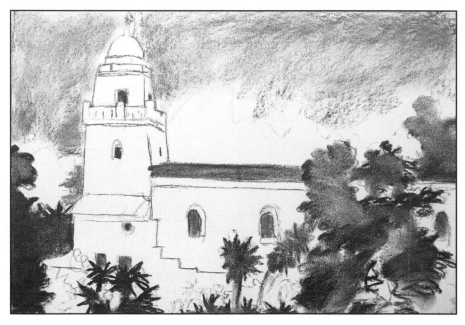

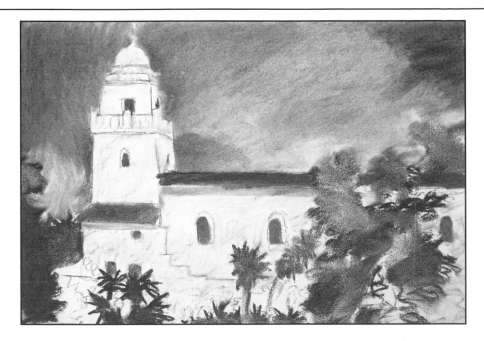

Step 3: Darken the sky, roof, and shadows until the building begins to glow.

Step 4: Use a sharp vine charcoal to define shapes and to redraw the perspective. The building must have a stucco texture yet stay light. A sharpened vinyl eraser seems to work well for creating this texture. Use a little white chalk to delineate shadows, branches, and foliage.

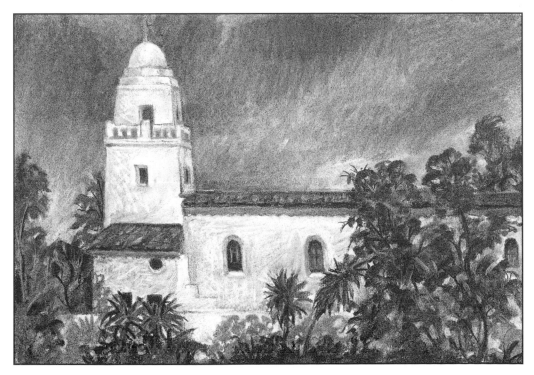

Still Life: Lower Eye Level

Still lifes need not be extravagant. You can take any items you have around and make them into a composition (e.g., tools, gadgets, dishes, desktop items). A devoted artist will find interesting patterns, shapes, values, masses, and light effects everywhere. This odd grouping became an interesting subject for drawing. My wife placed the massive candle holders on a desk with a walrus tusk, plastic egret, crystal egg, and bowls. One day, while I was sitting on the floor, I was attracted to the way the mass of dark shapes was silhouetted against the white background; the negative shapes were just as wonderful as the various objects.

This still life and the next one (pages 38–41) deal with two views of a similar arrangement. They both were begun as small pencil sketches, which I then translated into 18" x 24" color acrylic paintings. The charcoal drawings were done from the acrylic paintings rather than from real life. I often enjoy working this way because it gives me a chance to reorganize and distill ideas.

Step 1(below): Using vine charcoal, lightly sketch the composition. Drop plumb lines to see how various objects align. The egret is very centralized, but that is all right because this picture is really more about the way light is shaped by the dark masses than about the objects themselves. Because my eye level is at the tabletop, there are no visible ovals (see page 10).

Step 2 (opposite page, top): Mass in the darks and find a darkest value to set up the range of grays. Basically, the values are light, middle tone, and dark—a high key of contrast with few value transitions between each other.

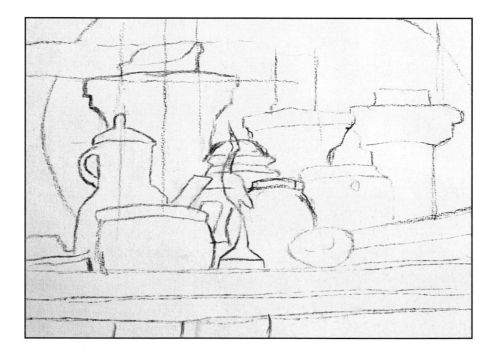

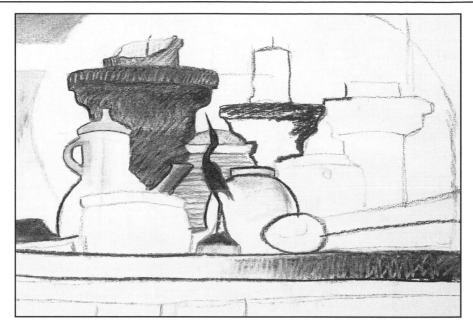

Step 3 (below): For this stage, crosshatch with a sharpened vinyl eraser and a sharpened vine charcoal. Pick out highlights with a kneaded eraser and refine the egret's shape. Notice that the left and right sides are handled differently to ensure interest, and some strokes stress verticality while others are left horizontal.

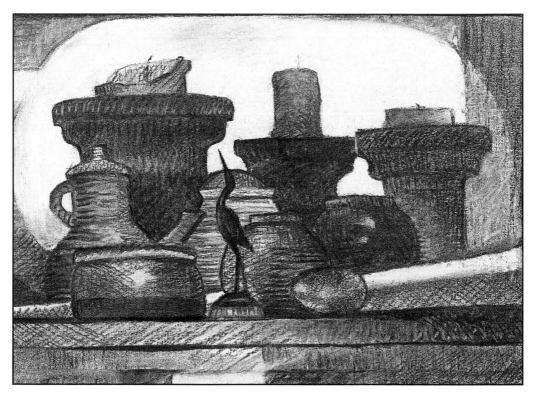

Still Life: Higher Eye Level

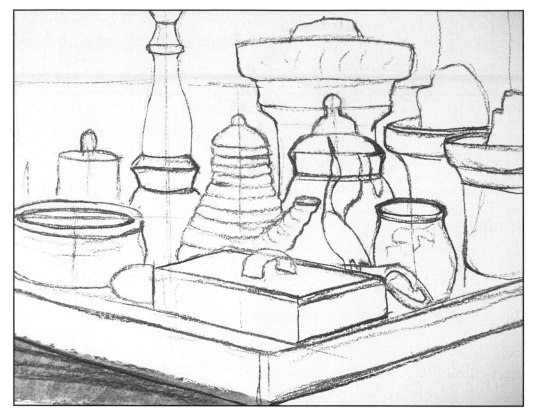

Step 1: In this still life, the candle holders and egret are moved to the right, and there are a few new objects, including a tall candlestick, and a ceramic box. Now the walrus tusk is only visible as an oval on the right side.

A good way to achieve symmetry in cylinders and ovals is to run a vertical line up the center and bisect the oval with a horizontal center line. If you are careful to draw all the angles correctly—as if you were tracing onto a vertical sheet of glass set up between you and the still life—neither perspective nor placement will be much of a problem. Eye level is at the height of the tall, dark candle holder, so the objects below it will be drawn from a bird's-eye perspective (see pages 10-11). Use sharpened vine charcoal and white charcoal paper.

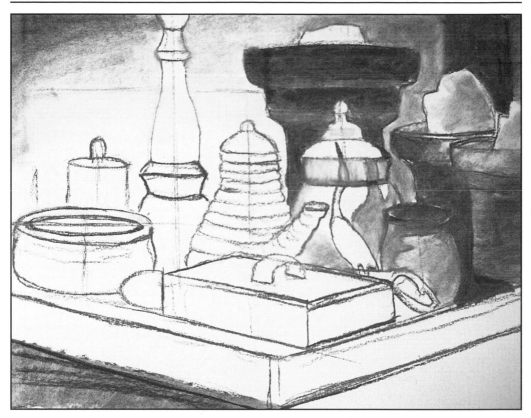

Step 2: With the previous still life there was no spotlight, only diffused light from a window behind me. This time, a narrow-range spotlight at left is focused directly toward the objects on the right. This makes the dark silhouette of the egret and its shadow on the white jar a focal point. Using vine charcoal, put in the darkest darks and lighter tones and soften them with a chamois cloth and your finger. The darkest tones eventually will require compressed charcoal, but for now it is better to stay a little bit tentative.

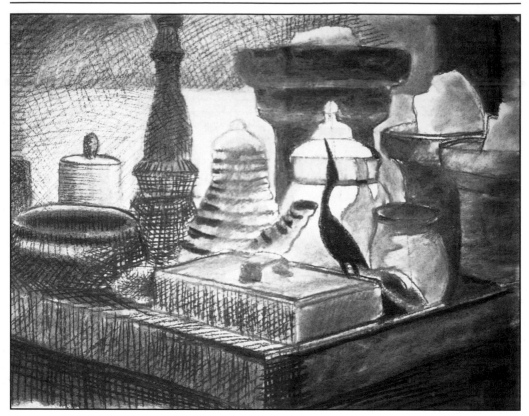

Step 3: Because of space, several progress stages have been left out so this stage suddenly looks much darker. It is difficult to get this dark using vine charcoal alone, because vine charcoal is very delicate and can dust off very easily. For more permanent darks, use compressed charcoal. The egret and other areas done with vine charcoal are now darkened with compressed charcoal and a charcoal pencil to make sure they hold their tones. These same materials are used also to crosshatch. I'm trying to give this drawing a dark, somber, etched quality with a lot of variant textures as well as sharp value contrasts.

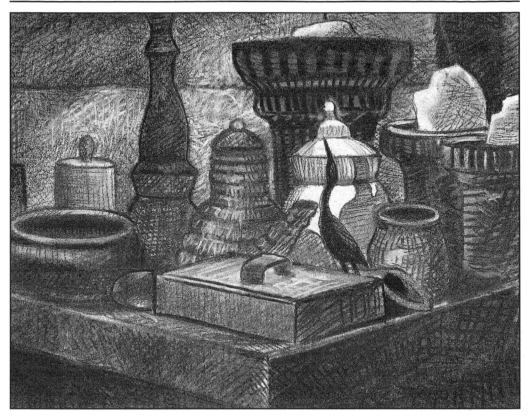

Step 4: After much of the cross-hatching is complete, a sharpened vinyl eraser is used to lighten the highlight areas. When the eraser is used on compressed charcoal, it needs to be cleaned after every third stroke or so by erasing it on a clean surface. There are several things to look for in this drawing: the dominance of darkness over light; textural surfaces over smooth ones; more verticals and diagonals than horizontals; and many secondary points of interest, even though the egret is a focal point. It is a drawing about complex spatial dynamics in a basically close key of contrast.

Portraiture and Figure Drawing

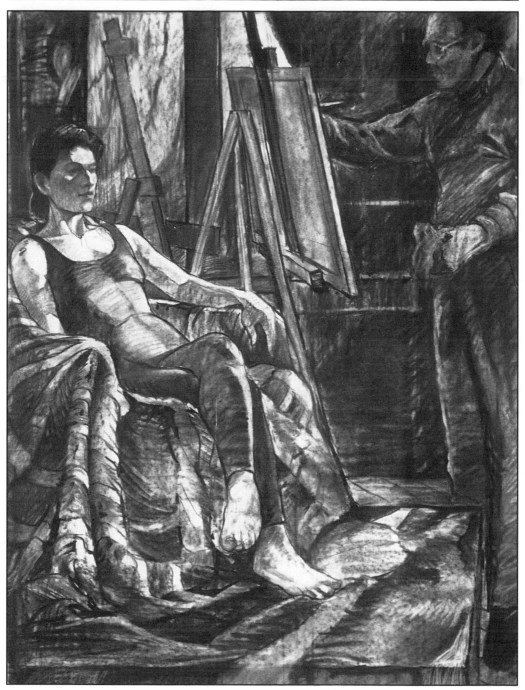

This large charcoal drawing on paper (50" x 38") is of my late artist friend John McKee. It shows a typical studio setup where the model is seated, well lit by a spotlight from one source while the artist stands at arm's length from his easel looking over his left shoulder because he is right handed. A timer is set at 20-minute intervals for a three-hour drawing session.

Anatomy for Portraiture

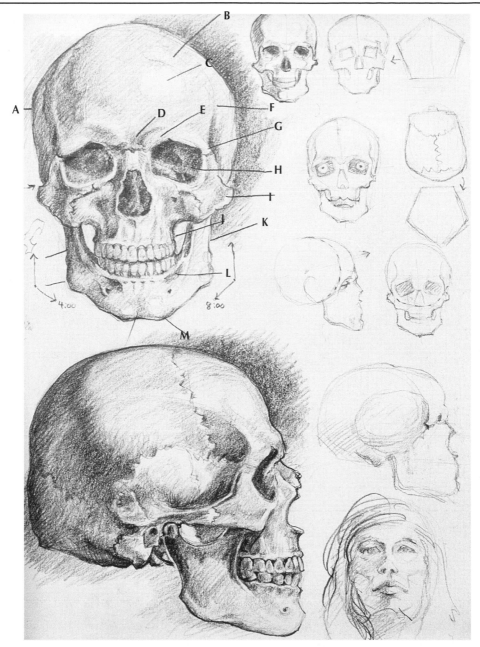

If you really want to improve your portraiture, get a plastic skull and a good book on anatomy, such as *Atlas of Human Anatomy for the Artist* by Stephen Peck. Draw the skull from all angles and copy many drawings from the book. The following are important skull bones to know: (A) parietal eminence, (B) frontal bone, (C) frontal eminence, (D) glabella, (E) superciliary crest (brow ridge), (F) temporal line, (G) zygomatic process, (H) orbit, (I) zygomatic bone, (J) maxilla, (K) ramus of mandible, (L) mandible, and (M) mental protuberance. At first you may think this kind of study hurts your spontancity, but it will actually give you more freedom as you grow. These skulls were drawn with charcoal pencil from an actual skull.

How To Copy the Masters

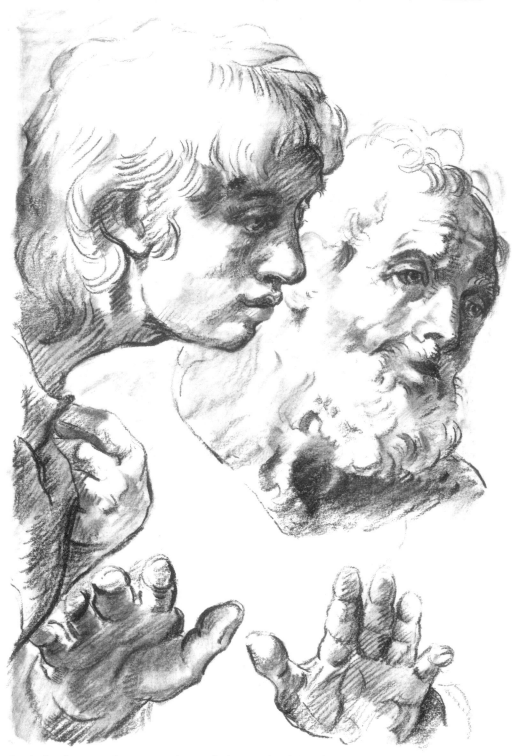

Study for the Transfiguration, charcoal after Raphael Sanzio

To learn the basics of drawing, almost every great artist copied.

To copy well is to choose to enter an exceptional mind. But choose the drawings you copy as you would choose close friends. Let them suit your natural rhythm and be life enhancing. They must intrigue you enough that you want to go beneath their surface. Copies need not be complete and they should never be imitations. Use your own gesture and handwriting rhythm. What you need to learn will become evident as you search, study and draw.

— Jeffrey Camp, *Draw—How to Master the Art*
Dorling Kindersley, 1981, p10

For a master such as Raphael (1483-1520), these portraits (opposite) were most likely working studies; for us, they are fine, polished drawings of heads in very difficult positions. The young man's head is almost a profile but not quite. Because the head is drawn from a slight bird's-eye perspective, we see a little more cranium and, hence, the center part of the hair (A). The part is important in this drawing because it follows the roundness of the head. The eye (B and detail B-1) is also seen from slightly above. Notice how nicely the eyelid wraps around the sphere of the eyeball. This fundamental is often overlooked by beginners. Raphael de-emphasized the older man's ear (C), allowing the younger man's head to come forward. This is a good example of knowing when to leave something out. Similar to the eyelids, the lips (D and detail D-1) also wrap around a sphere shape—the teeth and orbicularis muscle. The index finger is thought of as a block (E), and notice how cylindrical forms underlie the foreshortened hands (F). Raphael was very careful to keep the brows, eyes, nose, and lips in parallel alignment (G). Finally, notice how the nose (H) is a wedge shape and how Raphael shows its volume by carefully separating light from shadow. I could go on, but this gives you an idea of how you must think while copying a master.

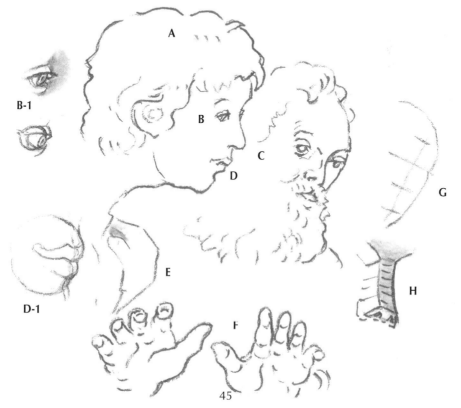

A Portrait on Toned Paper

Vine Charcoal, Charcoal Pencil, White Pastel Pencil, and White Chalk with Cross-Hatching—This portrait of my mother is done on tan paper. The warmth does not translate into black and white, but the values are still accurate.

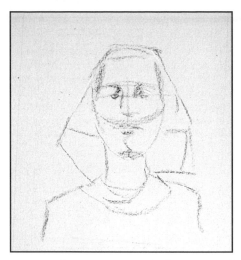

Step 1: Sharpen one end of a piece of vine charcoal and lightly sketch in the features, finding thirds such as chin to the nose, nose to the brow, and brow to hairline. (See Walter Foster's *How To Draw and Paint Portraits in Pastel, #HT240,* for more about proportions.) At this stage it is good to use mostly straight light lines for massing. The head is deliberately centered to convey a sense of "presence."

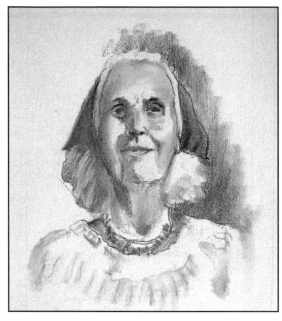

Step 2: Using a stump, generalize the shadow areas and establish the major areas of value: darks (scarf and eyes), middle tones (skin and hair in shadow), and paper tone low lights (skin, hair, and blouse).

Step 3: Now establish the lightest lights with white chalk, and key the other two values between the white hair and dark scarf. Refine the features with a kneaded eraser and begin to crosshatch over the toned areas. Make sure your charcoal pencil is very sharp for cross-hatching and that your dominant strokes follow the forms.

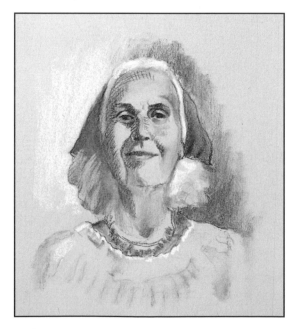

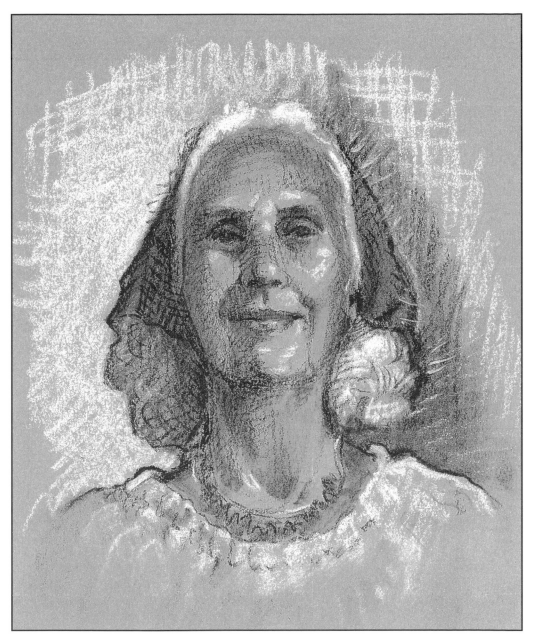

Step 4: Now finish by adding white highlights, but keep them subtle so they don't compete with the blouse or white hair. The same is true with the black cross-hatching; it must not be as dark as the scarf. Break up some of the edges with hatching and attend to the little details, such as the necklace and blouse, but don't overdo them or they will detract from the head. Notice how one side of the silhouette is sharp and crisp while the other is soft and sketchy. Always look for ways to add more variation to your work.

Sketching

These two sketches were drawn from magazines. When there are no live models to work from and you really want to draw, what will you do? Watch television? No! It is far better to grab your sketchbook and any kind of picture—photos, magazines, or master drawings—and practice. You can also set up a spotlight and try sketching yourself in a mirror. Choose whatever subject you like, but sketch! Often when you browse through your sketchbooks, you will discover that the little studies—never meant to be seen by others—are real jewels.

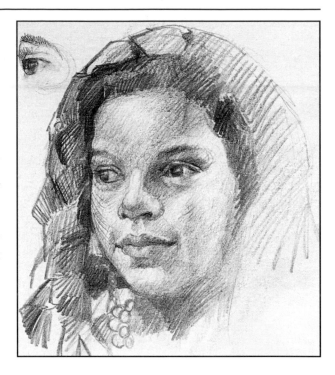

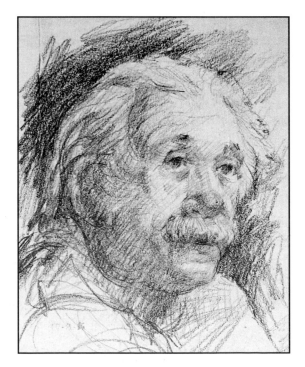

Do not underestimate your small, seemingly insignificant, studies.

People say, 'It is only a sketch.' It takes the genius of a real artist to make a good sketch—to express the most important things in life—the fairness of a face—to represent air and light and to do it all with such simple shorthand means. One must have wit to make a sketch. Pictures that have had months of labor expended on them may be more incomplete than a sketch.

—Robert Henri, *The Art Spirit*, Harper & Row, 1984, p96

A Portrait on White Paper

This portrait of my wife, Stephanie, follows the same development as the six-hour pose shown on pages 54–57. A portrait drawn on white paper differs mainly from one drawn on toned paper in that the charcoal must be darkened slowly, because light comes from white paper tone rather than white chalk. After lightly sketching and massing with a stick of sharpened vine charcoal, switch to a 4B charcoal pencil and lightly crosshatch over the toned areas. The hair and jacket on the right side are deliberately left unfinished to maintain a focus on the face. The goal in this particular portrait is a quality of softness. Each time you start a drawing, visualize a feeling to work toward.

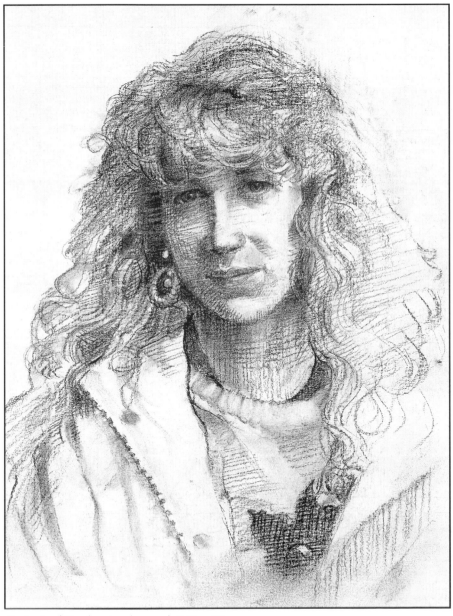

Portrait of Stephanie, charcoal (12" x 9")

Figures

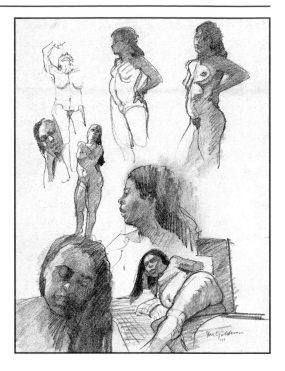

There is nothing in all the world more beautiful or significant of the laws of the universe than the nude human body. In fact it is not only among the artists but among all people that a greater appreciation and respect for the human body should develop. When we respect the nude we will no longer have any shame about it.

> —Robert Henri, *The Art Spirit*
> Harper & Row, 1984, p47

It is said that anyone who can draw or paint figures well, with deep understanding and knowledge, can also draw or paint a myriad of other subjects. This is because the human figure is constructed with all the basic geometric forms. The subtleties of technique required to construct a figure successfully are far greater than those required for animals or landscapes. The following pages contain examples from figure-sketching sessions, a step-by-step demonstration, observations concerning three dimensions, and an example of semiabstraction.

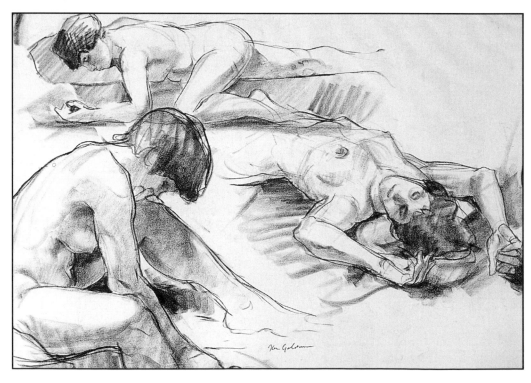

Massing Forms

The primary reason for study of mass and volume is the development of a sensitivity to three dimensions. To illustrate this premise, I have copied two drawings by Luca Cambiaso (1527-1585). Both drawings illustrate some of the best-known uses of simplified geometry. Cambiaso demonstrates how an artist uses blocks and cylinders to clarify front and side planes of objects, and then, by throwing light from one direction, lightens one plane and shades the other. Cambiaso did not use models for these drawings, but you can be sure he drew from many live models to arrive at this point. All drawings in this book are conceived in terms of simplified geometry. It is especially important to think of figures in geometric terms, because we draw best what we know well. Blocks, cylinders, and spheres are much easier to draw than complex human forms.

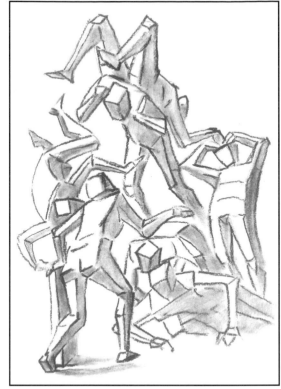

Group of Figures, charcoal after Luca Cambiaso

Christ Leading the Cavalry, charcoal after Luca Cambiaso

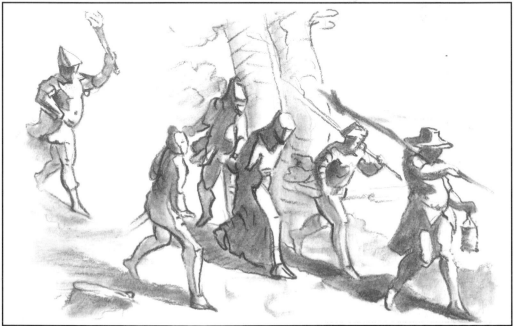

Figures: Warm-Ups

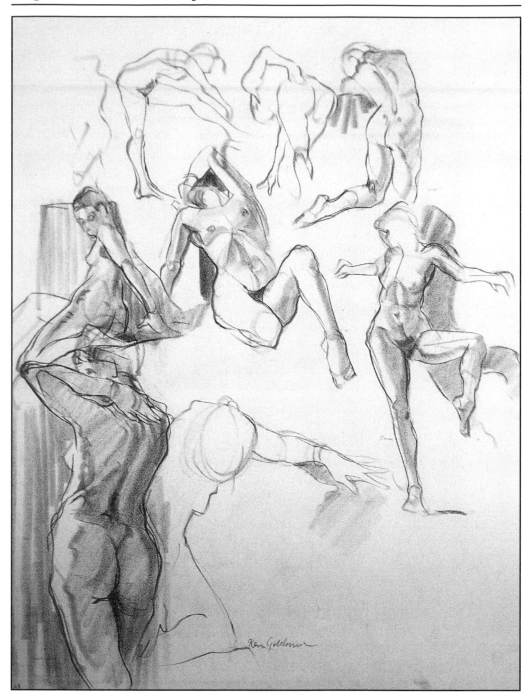

Most figure-drawing workshops begin with warm-ups. The top figures on this page are 1-minute gestures, the second three figures took 5 minutes each, and the bottom figure took 10 minutes. I am a believer in anatomy. Notice the anatomical landmarks in all figures, including the 1-minute gestures. I start my drawings as simplified block figures and add contour lines, volume, and shading—in that order (see page 15).

Figures: Rhythm in Line and Tone

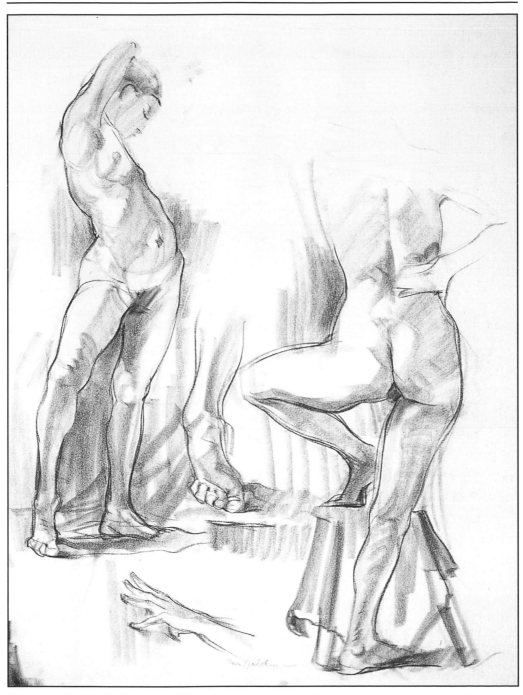

After two or three 10- and 15-minute poses, we usually end with two or three 20-minute poses. The figures on this page were begun exactly like the warm-ups, but in 20 minutes there is more time to stress rhythm in line and tone and to do hand and foot studies. Note the use of dark lines, double lines, light lines, and no lines to create visual interest. Once again, anatomical considerations such as rib cage, pelvis, and navel are evident.

A 6-Hour Pose on Larger Paper

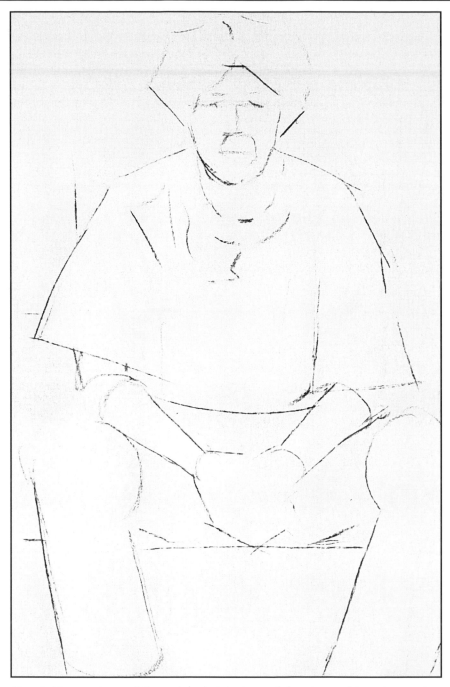

Step 1: To pass beyond the quick-sketch stage of drawing and to gain genuine knowledge of form, rendering, and composition, it is good practice to work on a larger surface with no rush to finish. Pin a sheet of sturdy 38" x 25" paper onto half-inch foam board, and sharpen a piece of vine charcoal. Block in the figure with straight lines.

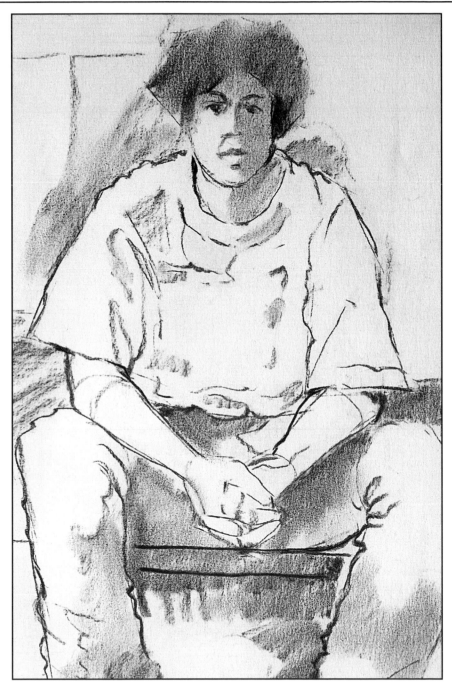

Step 2: Using one head length as a measure, double-check your proportions. There are nearly four heads in the total length, and the third head lines up with the hands. Now use vine charcoal to add contour lines, features, shadows, and darks. Soften them with your finger or a chamois cloth.

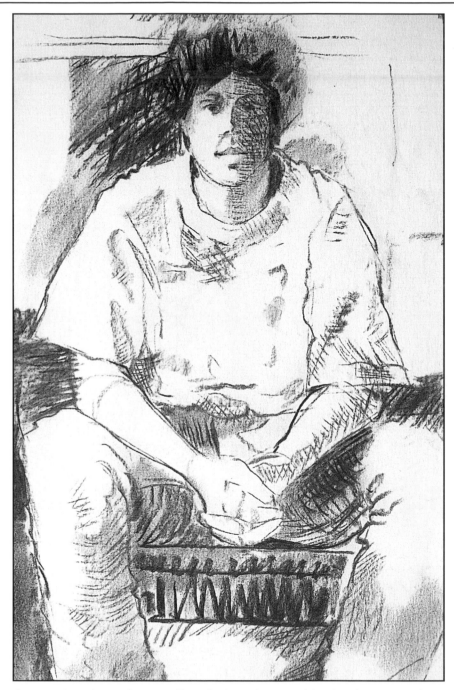

Step 3: Vine charcoal wipes off easily, but when you blend and repeat applications over and over, it gradually gets darker. Because the features are placed properly and the lights and shadows are clearly defined, cross-hatching and selective darkening can now take place. For design purposes, add horizontals to counter the verticality and darks next to darks so edges can be lost.

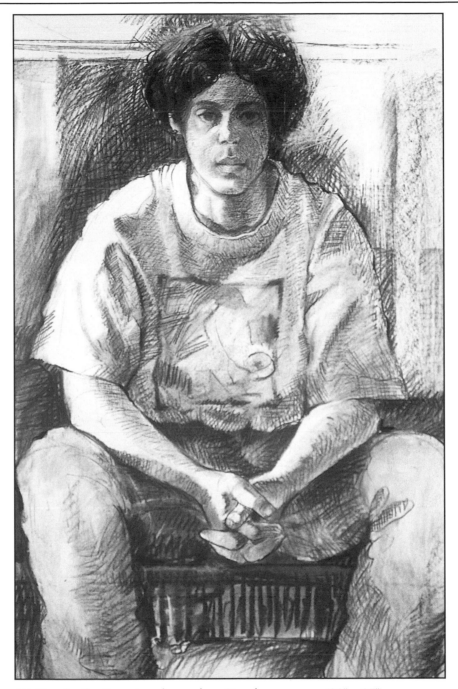

Waiting for the Bus, vine charcoal on Stonehenge paper (38" x 25")

Step 4: Finishing touches, such as the strokes next to the head and on the right side of the paper, are done with a sharpened vinyl eraser. Important dark areas, such as those next to the head and seat, are softened so they won't seem too busy. The folds on the shirt are rendered with the left-sided light source in mind.

Foreshortening

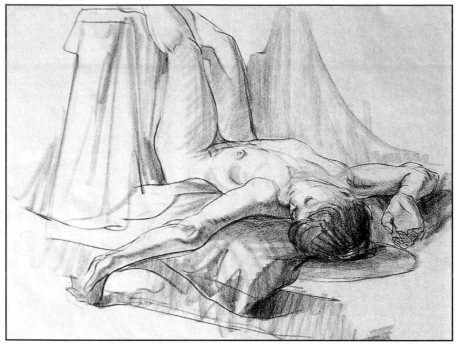

Repose, compressed charcoal on layout bond paper (19" x 24")

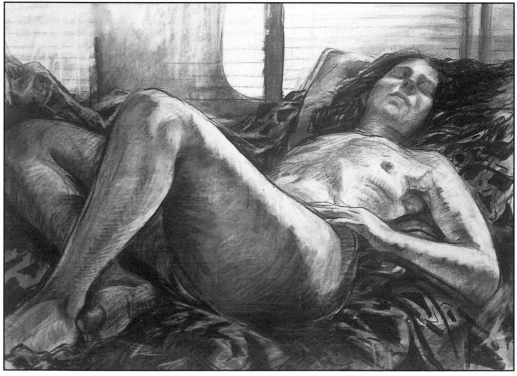

At Rest, vine and compressed charcoal on Stonehenge paper (38" x 50")

Arms, legs, and fingers are similar to cylinders; palms and torsos are like blocks. When you need to foreshorten, first make your figures look like either of these examples (at least mentally) so you can fully understand the basic forms and planes that underlie the volumes you are trying to draw. **Step 1:** Pay special attention to making correct angles and negative shapes; draw exactly what you see as basic forms, regardless of how strange they look. **Step 2:** Add the "realistic" outer contours to "correct" the simpler forms. **Step 3:** Add shading to create volume. If you like, exaggerate close-up forms a little so they come forward.

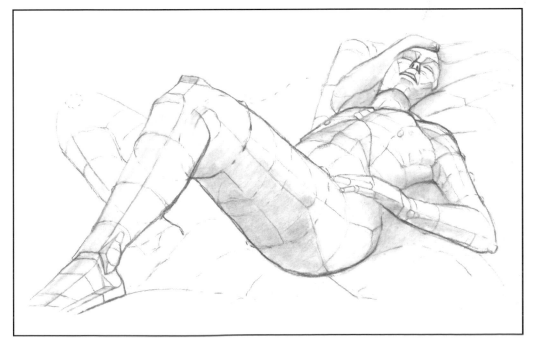

Solidity

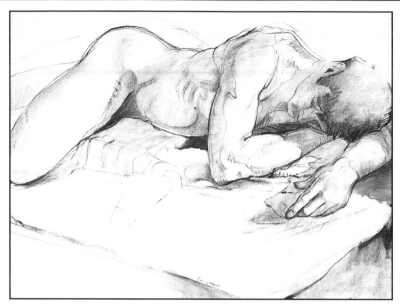

Reclining Male, vine charcoal on Stonehenge paper (38" x 50")

A drawing can look very solid with little photographic rendering if the strokes have the right values, are placed properly, and follow the forms. To learn these skills it helps to copy the masters and discover the shorthand drawing symbols they used to solve the same drawing problems. (A) This cast shadow begins darker and gets lighter as it moves toward the figure. The lines near the thigh indicate a fold because they follow the direction of the form. (B) Notice how the little strokes follow the sartorius muscle. They indicate placement and direction of the shadow on the leg. (C) The line of the latissimus dorsi muscle is in front of the external oblique muscle, which overlaps the buttocks, so there is a sense that each muscle group has its proper place. This shows the importance of overlapping lines. (D) The latissimus dorsi muscle is

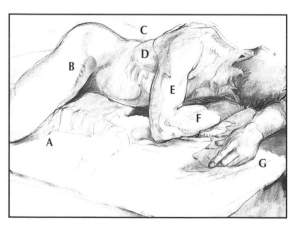

thought of as an egg shape, but it is rendered subtly. In the larger scheme of things, it is still part of the chest and must be subordinated to the overall shadow around it. (E) There are no lines in nature, but artists use them anyway because they are an expressive, economical way to symbolize transitions from one form, shadow, or plane into another. This line represents a shadow core and tells us where the form turns. (F) A cast shadow must reveal the form that it follows. If this shadow didn't show the anatomy of the forearm, there would be no reason to include it. It is up to you whether to use a cast shadow. (G) The hand is thought of as a block; the cast shadow on the wrist reveals its shape. The fingers are like long rectangles with spheres for knuckles. Note the top and side planes of the index finger.

Less Is More: The Art of Selective Erasing

Sometimes it is hard to know when to stop. Often when we do something that works well in a drawing, we think, "That touch was good, I think I'll try it here and a little there." Before we know it, the "little touch" that worked so well in one area is now in too many places and the magic is gone. It is easy to overwork a picture.

As a remedy, put your hand over an overworked area and ask yourself, "Is this area really necessary? Can the painting still work without it?" If it can, begin selective erasing with a vinyl eraser so the viewer's eye can fill in the spaces. The following describes how I simplified certain areas on the figure below.

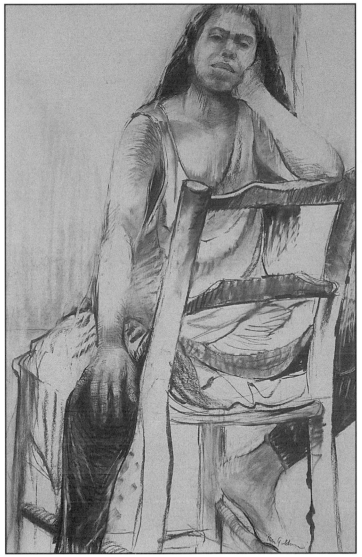

The left side used to have tone. Hold your hand over it and imagine how it would have looked dark. I thought shading on the left made the darks in the portrait less effective, so I decided to erase them.

The chair was deliberately left unfinished. In real life it was very dark, so I had begun to tone the left front leg in my drawing. I quickly found that the chair detracted from the overall line quality and erased it.

Look at Dorothy's right hand, right arm, left heel, and left thigh. These are examples where an eraser is used to eliminate unnecessary lines, soften edges, add variation, and create interesting textures. These simplifications help to enliven the drawing.

Dorothy, vine charcoal on Canson paper (44" x 36")

Semiabstractions

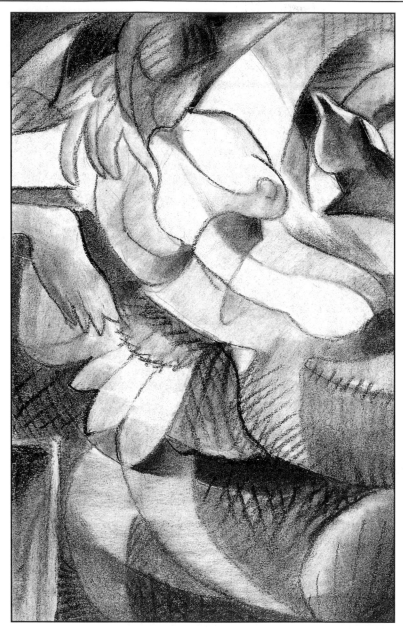

This diagram depicts a few abstract principles underlying the drawing at right. Notice the wide range of light and dark values, the variations in texture (hatching, erasing, blending, line work), the dominance of curves over straight lines, the repetition of the large sweeping arcs in the overall gesture of the figure, and the counterpoint of interest—a cat whose ears are similar in shape to the petal-like forms under the figure.

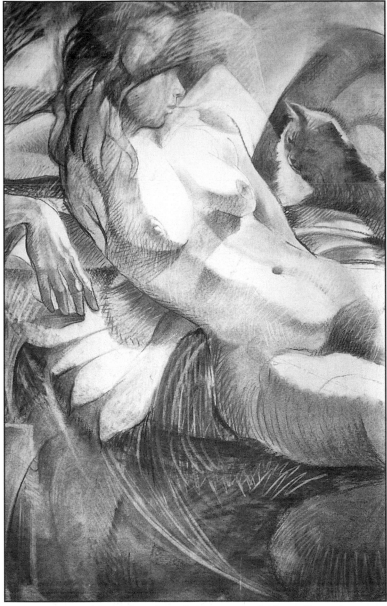

Cat Nap, vine charcoal on Stonehenge paper (38" x 25")

When an image is easily recognizable, but certain parts are slightly distorted, lost, or rearranged, it is said to be semiabstract. The more an artist retreats from realism, the more abstract a painting becomes. But no matter where a piece lies on the scale of abstraction, strong value structure, good design, and solid composition are still criteria that separate good drawings from bad ones.

This charcoal was drawn from a model, but the figure was thought of as semitransparent, which allowed the large flowing movements to go through the model as well as around her.

Final Thoughts

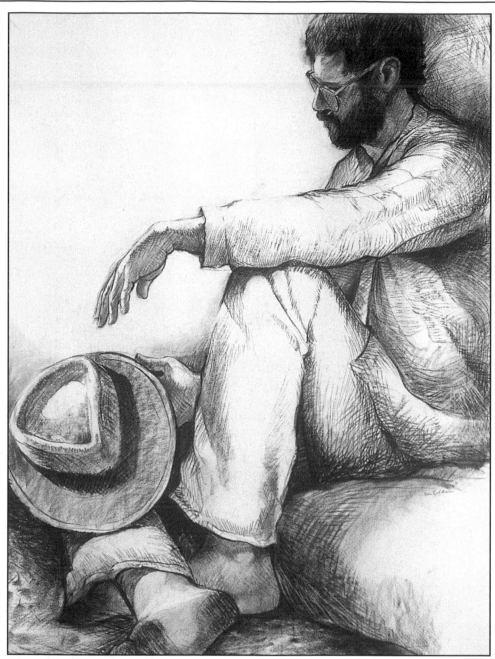

Man with a Hat, vine charcoal on Stonehenge paper (50" x 38")

Even if you don't have a studio, set up a workplace somewhere and keep an ongoing project easily at hand. Go to it whenever time permits; drawing for 10 to 30 minutes a day is better than one hour a week. Remember: Do not think your drawings should be immediately perfect, just make them a little better each time you work. You may have great ideas, but without the discipline of drawing, they will be difficult to realize. I wish you much success.